CW00548107

Ha

Supported using public funding by
ARTS COUNCIL
ENGLAND

Supported using public funding by Arts Council England

ISBN: 978-1-913642-89-1 Green Edition

Book designed by Aaron Kent

Typeset by Aaron Kent

Broken Sleep Books (2021), Talgarreg, Wales

Contents

Hit Points Green

Matthew Haigh
&
Aaron Kent

Introduction: Green

Growing up, my brother and I didn't always get on too well. We argued quite a lot (not really unusual sibling behaviour) – but the one thing we both loved was playing video games together. Whether it was 2-player on Donkey Kong country in my brother's bedroom, or gathered round the latest console at Christmas, games formed a constant tether between us, something we could always come back to no matter the argument. To this day, we still reminisce about that golden period of 80s and 90s gaming.

In this collection of poems, it becomes clear that this bonding over video games is a shared experience for many. Popular culture is often overlooked in much poetry – it carries a certain stigma with it; that it is somehow not serious enough, or not worthy of poetic contemplation. I wholeheartedly disagree with this. Popular culture – video games, films, TV shows, music – forms the anchor around which so many of our memories are weighted. Popular culture is the meeting place where connections with other humans are made. For this, and many other reasons, it is fertile ground for poetic inspection.

When sifting through the submissions for this anthology, Aaron and I noticed early on that a great number of the poems were along the lines of I remember playing games when I was a kid, those were the days... I may sound contradictory here, as that pretty much sums up my first paragraph in this introduction, but we both knew this was not the particular road we wanted to go down. Nostalgia has a strong pull, but usually isn't enough to carry a whole poem on its own.

The most successful poems – and the ones that form much of this anthology – are the ones in which video games serve as a vehicle to address universal issues, whether that be illness, mourning, beauty, identity, or the broad spectrum of love. There is also a strong selection of experimental work here, where the poets allow language and form to take off and pulse as brightly as any richly-drawn Metroid planet.

Video games are routinely misrepresented by the media as violent and addictive, an overall pollutant on the mind. I hope the diverse worlds explored in this book will prove counter to that. Player 1 – are you ready?

At the Core and Heart of the World

think silt water / think cherubic face of porcelain doll / think broken pieces peeking through / half a red smile / that's what recollection is / at family gatherings we were webbed with light / smeared and sherbet dabbed with it / softness from all sides / maternal in the yolk / this light my brother is what you now claw back to when you make lists of retro video games / in *Zool* the ninja claws down through the earth / layer upon layer / and beneath the membrane of soil / at the core and heart of the world / is such brilliant candy

In a dingy Omikron bar, he lives

a photograph changes imperceptibly once
 the person depicted is dead

 does the cloud scud across the earth or
does earth pivot beneath the cloud -

 this is the dance performed by my eyes
 & the photograph's skin

 *

Toward the end of the millennium David Bowie lent his likeness for two characters in the video game The Nomad Soul. The game was published by Quantic Dream for both Microsoft Windows and the Sega Dreamcast, in 1999 and 2000 respectively. He played both Boz - a jewel-skinned, techno-spiritual freedom fighter - and the bohemian lead singer of an in-game band called the Dreamers. In Bowie's own words, portraying these characters was like "playing the internet as a sentient being."

 *

I was afraid for years as a teenager that my brother
would find the JPEGs of naked men

on my hard drive

one day he did I knew he had even though
he didn't say anything it was a look
that passed between us

I stood there feeling the way vanquished bosses
in games do blood fizzing in its soft tubes
dirty dirty blood

& nothing left but a
cranberry stain

*

In 1996 David Bowie released "Telling Lies," the first downloadable single by a major music artist. To promote the release, he took part in an online press conference with two people pretending to be him. The three took questions; the real Bowie remained honest while the other two were, true to the single's title, telling lies. At the end, a vote was cast on whom participants believed to be the real thing. The genuine Bowie came in third.

*

my brother asked to borrow my laptop to download the song
I thought of the JPEGs nodded

*

It's been months since NASA announced they'd discovered a parallel universe where time flows backwards & even though it's since been debunked who can ignore an idea like that? I have some questions about whether

the parallel me is already unravelling back into the womb & ultimately back into my absent father's testicles like a sticky thread. At what point does the backwards aspect of time kick in? I walked through town once without wearing my glasses & for one second I thought I saw myself walking towards me, but it was just another guy with a beard. Diagrams online showed the backwards universe to be kidney-shaped & curled snug beneath our own. The effect was that the two universes formed interlocking L-halves of some kind of godly oblong.

if you fire up *The Nomad Soul* now even 20 years later Bowie
(in the guise of Boz) still unspools from the console
in a golden dress of data

 *

reading about the parallel universe at the time I could not help but think of my dead aunt
 I pictured her body as a froglet swimming above the yellowish highway
 (that molasses passage of time)
I pictured her soul as a glob of cooling wax floating up from our universe into the
 backwards universe

 (the treacle-fire of lava lamps)

 passing through the membrane of hell
 into heaven or vice versa

 who knows

we were never a religious family but I've always half-wondered
 if the dead are watching me & if so is my aunt looking down through
 the periscope of that dimension discovering

the polished

stones of men

for the first time that I like men that I like
& is it painful for her having no mouth
with which to exclaim what

*

Sometimes when napping I imagine
each iris slipping round to the backs of my eyeballs
like loose change down the sofa I wonder

is this what death is a shoulder shrug a lie
down in a warm bath

I walk to the house where she lived
feeling all unnecessary

how must it feel to see the face of someone you love
licked onto a 3D sprite?

how must it feel their face all topaz
a frozen waterfall

*

When someone says they saw you on the bus, but it wasn't you — is that your face glitching through time?

*

If time flows backwards in the parallel dimension does my aunt have a brand-new body, upside down & back to front? Or some new configuration of flesh, her skin the plastic pallor of a lime-flavoured Twizzler?

*

If you fire up The Nomad Soul now you'll find

columns of blue smoke

rendered in dodecahedrons

shamanic soothsayers shaking polygonal booty should be

an icy calyx where someone's face

 you'll find

a club where mist FX blur the scope of what is

 possible

 the pancake

 lipstick stripper's bob

& blinking in

fluorspar

 motherboard's

 limoncello neon the

 the

 in

 honeycomb

 Bowie

 the dead

 but

 dead

 not

 queen

MATTHEW HAIGH |45

To Be This Good at Nothing Takes Ages

Ryo Hazuki is rubbish at talking to girls
I.D.S.T. I mean Ryo
I know your father has just been killed
by a mysterious Chinese kung fu master
known only as 'Lan Di', but
Nozomi is so obviously into you
and that busy-avenging-your-father's-death patter
doesn't fly with me
when we've spent the last six hours doing nothing
but buying gashapon from every toy machine in town
then holding the prizes between our thumb and index finger
and rotating them while looking at them closely
I mean she literally just told you that she's moving to Vancouver
don't come crying to me when you lose her, is all I'm saying

Ryo Hazuki is rubbish at talking to everyone
I mean Ryo come on mate
I know smartphones haven't been invented yet
so if we don't know how to get to a place
there's little choice but to ask for directions, but
while you're at it it wouldn't hurt
to ask after your community's well-being from time
to time would it
when they've obviously known you since you were yea high
not trying to be shan here, I'm seventeen too
believe me, weird in my own skin ambling for elsewhere
but if you close yourself off to other people
you're fostering internal conflicts that may take years to resolve
trust me on this, and I didn't have a kung fu master to contend with

Ryo Hazuki is rubbish at achieving his goals
ach you and me both pal
yes, it may be true that your every waking
thought is animated by the vengeance you
will one day wreak upon Lan Di, but
the heart wants what the heart wants

CALUM RODGER |16

primarily a dynamic weather system, realistic day/night
cycle and, above all
an open world
and yes I spied that Sega Saturn in your bedroom
so I know you know exactly what I'm talking about
you and me Ryo were raised among the sprites of arcadia
then rent unto the polygons of consequence and sin
so it's no surprise that all we've ever wanted
is a diegetic ambience to do sweet nothing in

Ryo Hazuki is rubbish at making money
dude! we're so similar man
mind that time we tried to wait for the bus
it was raining, we stopped at the tobacco kiosk first
I think, but
I couldn't get my head around
the fact that all we had to do was wait, in like near-real-time just
being in the rain
I'm still ashamed to admit that I dinghied you then
given all that came after, what with the drugs
and you virtually bankrupting Sega
I mean seriously what were we thinking?!
we were neither of us Sonic, nor were meant to be
but boy do I envy you not knowing what modernism is

Ryo Hazuki is rubbish at staying in touch
all good Ryo I totally get it
people grow apart, grow older, one generation
replaces another (like Xbox ffs who saw that coming)
systems change, that's progress, but
I still think about you a lot
like when I walk down a rainy street to nowhere in particular
in a nowhere to be
oh by the way, before you go, did you ever
find out why it was called Shenmue? lol cool it doesn't matter
it doesn't matter that you'll never defeat Lan Di
nor that chronological time is alas not a sandbox
because I'll never forget how we'd share a can of fizzy juice
you'd down it then make a weird wee face and say 'ah, good'

Immortal Kombat XVIII

thee VS. summer's day
FIGHT!

hold L to power tap R to steady
<u>loveliness gauge!</u> <u>temperateness!</u>

block rough winds with ← on the D-pad!
counterattack with ↙ ↓ ↘ → + Ⓑ to shake darling buds!
when lease hath all too short a date
rapidly tap Ⓐ to extend!
when eye of heaven shines too bright or dim
press Ⓧ to cool + Ⓨ to brighten!
when fair from fair sometime declines
tap Ⓑ to trim the changing course!
keep possession of that fair thou ow'st
engage eternal summer mode
+ when thou wander'st in Death's shade
button-bash to outbrag Death!
as sure as thumbs can press and eyes can see
doth these eternal lines FINISH THEE!

3 ecchoes for ecco

1.

in home bay the sky
is #4265c5
and its yamaha tones
are like untelephones
the bivalves and fish
are pastoralish
in water so pure
my ecco, allure
all my sport is with you
in the ecchoing blue

full as a glass
in a convex glass
arcadian sprite
unteach and delight
to glaucous abandon
my pixeled zuhanden
thy pod and thy pond
my water'ssplashsound
all my sport is with you
in the ecchoing blue

till a fateful leap
renders depth of the deep
in water made bare
with fear and with care
so we die my dear sprite
for a bit and a byte
as thy sonar antiphon
intimates polygon
but ecco,oh, all my sport is with you
in the ecchoing blue

2.

the marks on your head look like stars in the sky

ecco is sprite is pixel is cartridge is tide
is dolphin is cursive is form is contentment
is lowercase is being is natural is lsd
is play is be is essence is real
is illusion is innocence is vapour is digital
is moon is magic is beauty is clearing is star
is 2d is sesame is sustain is hippy is release
is being is being is being is being
is eden is cosy is intimate is sine
is haunting is real is divine is happy is ecco

vortex is feeding on the seas of our earth

vortex is polygon is texture is loadscreen is telos is avatar is
autocorrect is formal is content is
grammar is ontology is nature is ketamine is
game is mean is appearance is real is
illusion is experience is wave is analogue is
phase is trick is sublime is cleaving is rock is
3d is cheatcode is attack is punk is decay is
ego is thought is speech is discourse is
sin is cold is vast is sawtooth is
haunted is sensuous is human is trying is echo

if we breathe air why do we live beneath the waves

3.

now as then
the most beautiful game
of the 16-bit era
is impossible

despite (or because of) the infinite
lives ecco the dolphin
this heroic dolphin
star-spelt eco-arche-agonist

who must defeat vortex
to save their pod and all of life
fails, fails utterly
in these small palms –

but i loved you ecco, years ago
when my heart was full of frosties
and i long for you this evening
amid these terrible acoustics

pretending there's a message
in the game i never finished
the promise of an ocean full
of you and other objects

ecco, if we breath air why
do we live beneath the waves
i who is echo of atlantis
have made these glyphs for you –

the marks on your head
look like stars in the sky

Canonically, Mario is 24 years old

Mario loves tennis
and Miyamoto is happy.

Miyamoto's hobbies include
long distance gardening and horse dentistry.

Did you know that in
Hotel Mario (1994)

when touching Mario's soft belly
at the main menu screen

Mario won't laugh
on days of national mourning?

Miyamoto -
you visionary!

Miyamoto keeps a bag of human hair
in the pocket of his breezy chinos.

Only Miyamoto knows
the *real* Mario died in '86.

He has only ever raised his voice
once, when the CEO

demanded to make Mario older and
more prone to severe anxiety.

Please understand that when
he is at his workstation, keep quiet

because although the technology
isn't quite there yet

Miyamoto is working on a game
where Mario can fly forever.

In Pipes

You can go your whole life
never knowing the measurement of a world
or how to keep your legs still,

dreaming in arresting 16-bit
without realizing how close it is.
Enemies you have never imagined

lay in wait,
barking dogs on chains,
slavering at your scent

as you dodge bullets
and hunt for mushrooms
aboveground.

It's when you're in the pipes
that you understand.
When your view of the sky

is narrowed to a pinpoint
above you,
it's easy to remember who you are:

far from home,
a man on the run.
You can imagine,

briefly,
the end;
you can tell yourself

that you're in control.
But you know
in your heart

and all the spaces in between
that there will always be
another pipe.

The New Kid

A single brass-clad ruble, lodged in the coin door of a pinball or pachinko table. It slinks at last into the innards of the machine,

and here you are, the new kid, tossing boyhood over your shoulder. Like a scarf. Like a skin. Someone has thrown the switch, called you to your own incendiary summit.

You become yourself. But there are sirens, soldiers. The Atomgrad transforms into a live current of scales and talons. Ministers, chairmen, councils and committees knit themselves into a raised and trembling frill of opposition.

They call you foreign agent. They douse and deny you. If only they could damp you down, they say, they will study and absorb you. And when you open your mouth to plead, you expose your pitchblende tongue, its deadlyish dark-sparking.

What you are is savage, splayed and clawed. A protostar, a spurt of hot sand. A terrible boy. A handsome, terrible boy.

Drybones

Neat skull　　　　Lucky mandible　　　Last dance
　　　　　　　　　Trocken knochen
Bickering heap　　Bust ribs　　　　　Invisible suit
　　　　　　　　　Huesos secos
Birdsnest bustle　Fused scutes　　　 Quick knitting
　　　　　　　　　Skinen bein

　　　　　　　　　If your breath
　　　　　　　　　will not enter
　　　　　　　　　this poor
　　　　　　　　　shell,
　　　　　　　　　I would have you
　　　　　　　　　wear me
　　　　　　　　　as a charm

Buttressed atlas　Slain tortoise　　　Sucked drumsticks
　　　　　　　　　Ossa secche

Undead Corsair

after Edwin Morgan, Jen Hadfield, The Secret of Monkey

Island, Monkey Island 2: LeChuck's Revenge *and* The
 Curse of Monkey Island

What I love about hate is its spectre, then its zombie
What I love about hate is its *barbe flambé*
What I hate about hate is its dumb, dumb drumbeat

What I love about hate is its split sail
What I love about hate is its spell
What I hate about hate is its foreshadowed last act betrayal

What I love about hate is its voodoo throne
What I love about hate is its gibbet cage and full moon
What I hate about hate is its way round a tune

What I love about hate is its fine leather jackets
What I love about hate is its quick wits
What I hate about hate is its macaques and parakeets

What I love about hate is its grog
What I hate about love is its Dinghy Dog
What I love about love is its "Bring me my bride" monologue

Genie Codes

N **E** **S**

L0NG3R N I 7R0 B0057
3NG I N35 4R3 1/2 PR I C3
7 I R35 C057 M0R3
5U5P3N5 I 0N I5 3X PR I C3

Bigfoot is a trademark of Acclaim Entertainment, Inc.

S **N** **E** **S**

$H()P$ D()N'7 74K3 UR M()N3Y
1NF1N173 B()MB5
<3S R357()R3 FVLL NRG
4LM()57 1NF1N173 M4G1CK

Legend of Zelda: Link to the Past is a trademark of Nintendo of America, Inc.

G **B**

I H17 4ND Y0V`R3 1NV1NC1BL3
D0N`7 FL45H 45 L0NG 4F73R G3771NG H17
574R7 W17H VII L1V35
34CH 574R 74K35 4W4Y @ L1F3

Kirby's Dream Land 2 is a trademark of Nintendo of America, Inc.

Encarta 95 and other animals

the disc that is the WORLD
~~an umbrella term for sexual and gender minorities~~
earth, as opposed to moon, which is made of
i never understood the word CHEESE
~~an umbrella term for sexual and gender minorities~~
milk from cattle or sheep or goats, those who can't cross
until a mouse runs over the GRID
~~an umbrella term for sexual and gender minorities~~
bars that are parallel, a grating
i call TOAST a rodent's revenge
~~an umbrella term for sexual and gender minorities~~
exposure to radiant heat, such as a grill or fire
pets have paws unless they have FINS
~~an umbrella term for sexual and gender minorities~~
a flattened appendage on various parts of the body
or suckers or just FEET
~~an umbrella term for sexual and gender minorities~~
plural form of foot
w/ jam, or honey, or marmalade made by BEES
~~an umbrella term for sexual and gender minorities~~
a stinging winged insect that collects
that dances & strokes the screen the TIGERS
~~an umbrella term for sexual and gender minorities~~
used in names of others such as moths, or worms
hide in trees on WEEKENDS
~~an umbrella term for sexual and gender minorities~~
regarded as a time for leisure
meanwhile writing verses SANS MERCI
~~an umbrella term for sexual and gender minorities~~
didn't you ever think I might be
when i have no homework i write QUEER
~~a person who is...~~ *a word that is like erase*

i need erasure

like a mouse needs an essentialist PARADIGM
~~an umbrella term~~ *particular syntactic role*

& all week i ask to play SNAKE
an umbrella term *move or extend with a twisting motion*
stop the beast from hitting the WALL
an umbrella term *protective or restrictive barrier*
one day i'll move to BERLIN
an umbrella term *a large bear caught between waterways*
i'll swim from the beach at WANNSEE
an umbrella term *are clams happy at high tide*
what is a BAPTISM
an umbrella term *a series of tidemarks*
without a CONFIRMATION
an umbrella term *the rite at which one becomes*
someone who will always be asking 'what is HEAVEN'
an umbrella term *when the sky is perceived as a vault*
or what is BLUE or BLACK
an umbrella term *the sky or sea on a sunny day*
or what is HERESY
an umbrella term *profoundly at odds with*
please remove the child lock for CRASH DUMMIES
an umbrella term *that simulates the articulation of the human body*
evidence of ESCAPE
an umbrella term *temporary distraction from reality or routine*
mum goes to HOSPITAL
an umbrella term *providing medical and surgical treatment*
to study infectious diseases like CHOLERA or
an umbrella term *often fatal bacterial disease of the small intestine*
i wash my hands under hot taps & ask about AIDS
an umbrella term *severe loss of the body's cellular immunity*
she is silent while i mask my love of the NAKED
an umbrella term *expressed openly; undisguised.*
the FATHER or the GIRLFRIEND
an umbrella term *(often as a title or form of address)*
work in the CIVIL SERVICE
an umbrella term *the permanent professional*
corridors walking toward the ward the CONNECTIVE
an umbrella term *words and phrases*
wearing a straw fedora otherwise known as PANAMA
an umbrella term *particular tropical palm tree*
a canal or PASSAGEWAY
an umbrella term hallway, walkway, gangway, aisle
doors opening & surgeon's gasping do not RESUCITATE
an umbrella term make something active or vigorous again

grasping fruit sun flesh FORBIDDEN
~~an umbrella term~~ *a transition between*
from Worms i learn the word KAMIKAZE
~~an umbrella term~~ *a deliberate end——*

Point and Click

"… every cook makes substitutions,"
you announce to the kitchen at large

while you improvise with that old red wine
and whatever remains of the spices. Silence

doesn't sit badly. The observation
is less the point than the interruption.

Thoughts shimmer across each surface
in splendid animation. Ingredients

gleam in their half-filled jars, solutions
awaiting the arrival of the right problem,

the right fork in the dialogue tree,
the right second to flick the switch

and *"balance these doggies!"* Since you discovered
your need to be an adventurer

at this least convenient time of life,
your very silences have swum

with incidental noise. The pot
bubbles and pops its inventory.

You resume the search for the right action
to prod the plot along.

Four Lists from King's Quest V

Some items: pimp cloak,
rotting fish (probably cultural),
heart-shaped golden heart,
custard pie,
a small spinning wheel,
fresh honeycomb,
piece of beeswax,
old tambourine,
a bag of dried peas

Wrong move and you'll be: frozen, drowned,
stoned, snakebit, trampled, stabbed, asphyxiated,
beared, beed, thirsted, toaded, spidered, scorpioned, vined,
thrown to the wolves, yetied, harpied, sea monstered,
eaten by a two-headed baby eaglemonster
lost in desert without GPS but with scary John Cage music
trapped in a secret treasure vault on piles of gold coins
stuck in a bottle meant for genie-holding
staring at your own tombstone with the message,
"Thanks for playing King's Quest V."

In 2020 it can teach us about:
white nationalist paradise
cultural appropriation/marginalized populations
minimalist environmental ecotourism
dumpster diving/exploitation of slaves/human trafficking
sexism and stereotypes in fantasy/gender roles
writing clichés/respect for differently-abled
invasive species/destructive tourism
upcycling/coping with quarantine
compassion to others/welfare

women can be:
fortunetellers,
damsels, princesses,

mermaids,
witches, hags, harpies,
ice queens

World 8: Expatriation

pockets of light into which I spill
liquid cat into ornamental vase meme

cul-de-sacs of challenge, refuge
ambient lighting spreads out from the corners
we are bowl-swilled, tipped out via the long neck, returned
to the ring-road migration scheme

this one path, before and back — occasional pitstops,
assurances, points of no return and no terrain
as far as I can see is as far as I want to see
the halo of that which I am able to conquer
a night without context has fallen around the torch beam

I can still fly in certain environments
these muscles remain to some extent wings
amphibious life is slow but welcome
my hand in the pond darkness is rich with gelatinous becomings

I cling to the pole, hit, fall
to applause, to the clatter of various cheap-to-produce metals
the machine, impacting against my torso, spews out coins
until my pockets are overloaded
thumbs sore from the act of pressing them in

the burden of carrying everything you have is weighed
against the merits of being contained in a single file,
a discrete pocket of information

you reach, and that space — finger-to-finger
constitutes a world

I am walking on a ship
or rather I am hugging the left-side of the screen
tiny steps like sprinting for a bus in heels
as the ship passes under me
relieved

You, a dwarf with an axe and a grudge

'Bringing peace to the land is my duty,'
you say, hacking your way
across a pixelated map.
Silent forests, riverbanks
you swing and leap
and swing again
but have you ever dipped
a toe in the mountain cool of a stream?

Little villain, boiling head
I want to let you lay
your weapon down,
blunt it flat with a stone.
You keep to your swinging
and the low sun watches,
shining like blood on a coin.

Outrun

Those unreachable mountains, thunderheads
massing, the pop-up orchards and instant rocks,
and the grey track unspooling beneath
our squealing tyres. However fast I drive,
my thumbs deep bruises on the controls,
we shall never reach it, that dream of an horizon,
a vanishing point of perfect cities and oceans
cinema-blue. I'm learning the dynamics
of this illusion. I turn to you between checkpoints,
ask about the people you've lost, share my hope
of a finishing line beyond this stalled traffic.
I accelerate past the empty fields and
we play the oldest clichés: time is against us
and the road is unforgiving as hell.

My Avatar

VOICEOVER:
In the early years of the Deep Web, I gained notoriety for writing and coding an RPG and its corresponding pseudonymic fan-fiction epic.

VOICEOVER:
In the game, love and time have been tamed by the implementation of caste. Only certain character classes are able to feel certain kinds of love, and correspondingly, certain kinds of time.

VOICEOVER:
The Filial Caste, with its Focus on the Family, is a paragon of decorum and loyalty. Familial love, brotherly love, monumental love, love of circular time. Bonus stage compulsion loops..

VOICEOVER:
The Filial Caste manages the Courtly Caste, who in turn, serve the Filial. The Courtly Caste exists in striated time, segmented time, time of leisure interrupted by the manufacture and sale of Pleasure Credits. An endless mode with dynamic music, destructible environments.

VOICEOVER:
As the game's popularity grew, I observed a niche stratum of Courtly players assuming the garb of Forensic Archeologist, a Courtly-caste character trope responsible for carbon-dating classified evidence of an extinct Romantic Caste unearthed in a system-wide Promotional Dig.

VOICEOVER:
The official history, as you know it, is simple: The Romantics were human waste; they cried and ate and fucked themselves to death, the promotional materials read. But you are about to discover a dark secret.

VOICEOVER:
Over time, Filial members reset their avatars and defected to Court-ly. They wanted to dig.

VOICEOVER:
Previously, my work had asked the question: why do humans crave the physical when the physical is become passé? Now my work inquires only of the cosmogony and cosmology of identity: how and when does a person begin? ("The Romantics lived only as long as what seized them.") Forgive my Romantic leanings. I am an information architect of beautiful pasts

VOICEOVER:
But what is *past?* I analyzed the game's engagement vectors and data constellations: favorite color of tunic (black), uses of punctuation (sporadic, extragrammatical), inflation and deflation of game credits (severe). IP addresses (urban and exurban, rural and pararural). I listened to players converse in my headset. Silence was a message equally as legible as anything typed.

VOICEOVER:

By now, I was late in midlife. My avatar remained unchanged. I understood that our archaic nodal interlacements understood beauty imperfectly. A butterfly isn't beautiful because its qualities are fleeting. A thing and its qualities aren't perceived as beautiful because of their limited duration within time's constraint. Rather, a thing's process of becoming reveals to us the gummy nature of time. Whenever the universe manages to produce a gesture, a multi-platform spectacle so striking as to disappear time completely: that's beauty.

VOICEOVER:

Process reveals spectacle's insufficiency to promise us anything

VOICEOVER:

I came to know process through searching. I used every search engine available to hunt myself, knowing that each algorithm would output its own mesh of meanstandardized battle segments. I unearthed avatars of different sizes at varying levels of pixilation. I uncached early critiques I'd penned of a rival company's RPG. I remembered the other designer, how neither of us, before the Federal Gender Disclosure Act, knew the other was a girl.

VOICEOVER:
Once, as a teenager, I joined a rugby match.
The club of my elbow caused severe internal bleeding in a man.
I queried and retrieved his data: birth, diploma, deed. A modest
bibliography in an extinct field. A list buoyed by voluminous logos
flashing beyond the page girth, scrolling up and down and over,
buffering and wheeling as product was birthed.

VOICEOVER:
I recalled the lyrics to his favorite song in fragments. I searched for the
song and found an incorrect transcription. (A series of slurs.)

VOICEOVER:
This was also the way I understood history.
History: Here I am, walking backwards, away from the cam-
era.

VOICEOVER:
Our sentences mostly started with "I."

I ate dirt.
I hate dirt.
I ain't hurt

VOICEOVER:
Once, I performed an analysis of his rival gaming system's battle-royale beta-release for a popular content aggregator. In the fallout from the ensuing flame war, trolls and bots multiplying exponentially overnight, my communication channels segued from public to private to public. This was the self I knew: I shaved their warrior head and captured the magnetic blue globe of their skull in my webcam.

VOICEOVER:
You can't see the glow. You can only see my avatar.

Being Shadow

On the off-chance that you might let me in,
I would sit compliantly at the head of your bed,
agree to have the dodgy controller, hoping to play
our relationship on fast forward for a while. Parkouring
to an arcade soap opera theme, you battered the buttons
and I felt the ringing in my ears. When my spin jump
didn't make it, you would turn
to look at me for the first time.

You're straight into rolling attack but
I am sat behind you, remember? Your aura stuns:
I would sacrifice everything. Maybe

we hit chaos control, but suddenly you are
sat between my two kids showing them
how to spin jump, quick-stepping rivals.
They may be the wind, but
we are closer than you know.

Twisted Flipper

You'd sit in the black chair closest to the television
 that coveted seat patterned with a patter of pink
lines like a steady rain and play a grey simulation
 of a pinball game in a dive bar somewhere in Calfornia
where you never run out of quarters and the beer
 is cheap but weak and you can hear the creak of leather
jackets and the rattle of silver buckles on belts and boots
 and smell sweat and the sticky bite of too much
hairspray and the glitter is everywhere bright and glinting
 as Mötley Crüe's riffs as they perform a stilted set
of the same three tracks from a flashing juke box
 except it's only you in our glam pink and black living-room
with the sound up mashing black buttons and flinging
 that metal ball up again and again and again as the band
cycle through those same three tracks on a second-hand
 Mega Drive

When I Knew You Were a Real Boy

You brought home the new shiny toy, wrapped in something that sparkled.
We plugged in, lit up, unplugged guitars, smeared lipstick on the back
of my hand to begin, saw in *ashtray Mondays, sit at home Tuesdays, pent up
Wednesdays, Sonic Thursdays,* and the bottle of cheep white wine.

Act one was passed fast, the ring bonus, careered into our Fridays, playing
to win. I thought it was a game. Started to laugh, that was a mistake
as you tumbled over all the obstacles, spinning for the loops, you got high
scores each time, higher then anyone else. You looked at me as I yawned

and said that spiky haired creature wants to go on chomping those emeralds
on the green hill, go back and get them, don't drop a point, and we looked
at each other and knew something I didn't want to say. That it wasn't a game
that drove you faster than me, more than I could stay up for, some superglue

to keep you posted to the station in front of the TV, opposable thumbs
ready to inhale victory in glittering fanfares, it was the win, it was the loosing
to fling you, cartoon kid, back to oblivion. I went to bed. I woke up on a smoky
Saturday to find you tapping your foot, sweat-streaked and wide eyed into worlds

you'd never imagined. I couldn't follow you, my mind elsewhere, on Felix
the Cat, on Micky Mouse, on getting away with it, perhaps. I saw pin-ball
splatter all over the flat and I swam into another level, no going back. We put it away.
You told me years later, you'd got bored, that game was too easy.

Tomb Raider II

We took turns with the controller. The graphics were glitchier than I remember.
Lara slid down a slope in the dark alongside the sound of a fading helicopter.
When it was his turn he couldn't find the water, a bright pool hidden behind
grey rocks we'd already come to twice. We needed to wade across and away
from the roaming tiger. I watched him get mauled three times. The level always
restarted at the slope, beginning again after Lara's body slumped and she died.
I showed him how to jump, then lift himself onto the stone block on the other
side. He didn't like to be shown by me how to cross the closed river. I noticed,
I didn't need to explain myself before, the way some parts of the land looked
carved in perfect cubes with sharpened corners. But there was also the other kind
of rock that seemed unhewn. It must all have been drawn this way by somebody
but I wondered how careful or knowing they were. The landscape drew attention
to its maker, but the why of the intended path was never shared with the player.
Hyper-created yet seeming arbitrary, like the careful martyrdom of a careless
martyr or like Lara. I led him to the hidden ledge where I could remember
an object waited, a little crystal figure that looked like a dragon or a piece of
paper scrunched up and thrown away. She made a sound of discovery – ahaa –
which I heard before we got there. I felt sure the mystery thing would still be
there with its specific shape. Asking him the question meant unknowing him
which meant the feeling of myself unknown by glowing and deep water. He
left early and out of habit I didn't ask him to look at me or hear the nothing
of me after. The silence when he'd roamed away was even louder. I came back
to the living room and watched her where he'd left her, breathing with her back
to me. Her body moved in repetitions, caught in a show of small and glitching life
as she stood astride a tiger, one he'd gunned down earlier by the water. An act of
self defense he'd say if we were still together, its body striped with past design.

cable club

but this was back when the only way for us
to make it work was to sit / knees touching

[*please wait…!*]

shoulder to shoulder / huddled as if scared
pulling too far away might upset the other

[*max waves farewell as* ___ *is transferred*]

in the same room but separate / we watched
the same scene play itself twice through

[*take good care of* ___]

two screens / everything oddly mirrored
we were hesitant but eventually agreed to

[*for* ___, *cal sends* ___]

a very specific deal / it was our first attempt
at trading / exchanging parts of ourselves

[*cal waves farewell as* ___ *is transferred*]

we didn't speak for a long time after / taking
everything in / we were so young back then

[*take good care of* ___]

and knew nothing of loss / only that we were
joined in the sense of experiencing something

[*waiting…!*]

together / then quiet / thinking of how it felt
to lean into someone else / to give and take

[trade completed!]

Pass me the controller

For Ben / and Jack

In the ice world of the attic / bulky cartridges and weird controllers /
launching stadium lights / the bird and the bear / so alight on a feeling /
all those gunfights / races on kitchen tables / cars so small /
so small and / you shouldn't play with that squirrel / you
shouldn't pick Oddjob / we can't even chop him it's /
where the moon is falling / over everything / it will / rewind
it so I can see it again / but / what even is an ocarina / if you fly
this way there's a slot machine / in space you can spin it here
let me / I know how to make the Royal Rumble go on / forever /
Charizard will burst from a volcano / if you feed it apples / and
I am emerging away from / why does the castle have her face
on it / why is there a / don't touch the piano / help / my flute doesn't
have teeth / this is a link cable we can / Mewtwo is my favourite because
he's lonely / because he's one of / he's gone wrong / well that's dumb
I like Jigglypuff / I wish we had Lara Croft / I think I've spun so fast
there's an imprint in my palm and I can't see that red mark
ever going away / but it isn't the same without / without three of us /
play the song the moon is falling / don't forget the / what exactly is a
terrible fate / it's scary in the sea because you can't fight back /
you just swim in the dark but the fish are faster and the fish
get you no matter how hard / did Bomberman build the pyramids / or
did he get his friends to do it / there's a slide in that window /
I know I found it / let me try / he's just a hand with eyes / he's not just a hand
he's a hero / he's basketball Hercules / did you remember to stop
the moon / to go back / play that yellow-arrow song / I've tried
but it doesn't / it isn't the / not anymore

VII

chips radiate in the microwave
Ifrit is called forth
rises from Cloud's command
every win a fleeting dream
somewhere your dad is being released
you wait for a comet on a white background
it is holier and it won't be long
until he leaves again
for what he won't know is the last time

there will be no avalanche of emotion when
a white orb falls from your dad
rejoins the lifestream
you will only wonder why Aerith's theme doesn't play
as the conveyor belt nudges him offscreen
wonder if Nabou Uematsu would have made this moment more
memorable
maybe there would have been more strings and less folk music
would the frame rate be different
is this just the scratch on the second disc that forces you to reset

A Love Letter to the Sega Mega Drive // 32-bit Escapist Drugs

You remind me of lavender talcum

powder. In a pink room of misplacement the scent

whirls with earth from worn trainers and nips

with potential. Peripherals held

tightly - to the chest.

Running, running, running

My grans fake pearls hang against a lilac painted

wall & button mashes rain. *Walk. Jump. Walk.*

A door from another world shuts and

voice finds the staircase to travel up.

Pixel-thrill is an *art drug illusion*

a Houdini-basking feat of escapism.

Eyes that follow a ball Neptune blue

can only focus on the immediate

&

when I think of you I wonder why

a kid would even need a father.

you are always Ryu, me, Ken,
fighting till our thumbs ache

tearing flame grilled *shoryuhens* from thin air ↑↓ X O
hurricane kicks ↓← X at end of level baddies and never sweep
someone on the floor it's bad etiquette *ROUND 1 FIGHT*
we are taking turns fondling the crisp packet, each time

you lean in I flash a sight of your forearms, lines like ←←← X
you can't keep doing the same move it's not fair *ROUND 2*
FIGHT we speak for hours but never really O △ Y speak
you're off school, Mama says don't mention it so we wrestle, seals

in sun anesthetized by screen-light, dinnertime, you always beg
to have dinner at ours, relaying combos ↑↓ X Y it's in the past
you say X O △ each bout redeemed *PERFECT* unscathed
 after school, *FINAL ROUND* your mum forgets to pick you up

I smash you 3 in a row, she doesn't turn up for hours,
10 in a row, doing my victory dance, laughing, but you're folded
in two staring at your joypad like the buttons are eating your hands
Ryu is lifeless on the tarmac, body bloody, *continue?* 10, 9

you're crying 7, 6 and I don't know, 4, what to do, 2 so I click
X and for the rest of the night I don't say a word, but let your
hadoukens hit me, again and again *hadouken* until
your mother carries your body away

The Night I Play Tekken 3 Against Death

Initially, a loading error means I have to take the disc out and blow on its underside. Death sits patiently and says nothing. Second time around, we're good to go. Versus. I settle on Jin Kazama, but then I have to show Death how to select a character. I don't think Death has used a Playstation before. I have to explain holding the controller with both hands. Eventually, we get there. Death picks Eddy Gordo. I try to go easy, given the skill gap, but pretty quick I watch Jin uppercut Eddy down to zero health. Death proves gracious in defeat, even when I take the second round with a perfect tsunami kick. We play again. Death switches character to King, but the rematch is much the same. I take two rounds again with minimal effort. I offer Death a break and a snack, but Death declines, intent on playing into the night. One by one, the house's other occupants go to bed. I point out that a list of special moves is available on the pause menu, but Death would rather figure it all out organically. I'm quick to leap onto this interaction and try to get Death to open up a bit more, but it's impossible to get any kind of rally going in the conversation. Death's reticence holds out and I lose count of the score, always me vitorious, no matter which character Death picks. I'm reminded of playing against a much younger cousin, Death with this similar refusal to rest, to maybe play something else or call it a night. My fingers sweat and chafe. Carpal tunnel kicks in. I try to stretch out the ache in my hands during loading times. I swig another energy drink. Grey daylight is visible through the curtain slit. Death lands a trio of punches. I feel the vibration of the combo through my palms.

Blockbuster

Battle. Clear a path.
Good spot, run for what you can

gather. Cram the gaps,
two more beats and then a blast.

Scatter. Sudden death.
Walk the lines between the walls,

frantic. Slotting in,
stand stacked in the sheltered spot.

Falter. Two more beats
and fire.

First Person

I heard you fingered Carla Bayes, at Wensum Park
in the summer holidays. You were in the year above
and you were Donna's brother's mate. So, weekends,
when Donna's mum was working late, we'd be
on the floor in front of their settee –
Donna's brother, you, Big Joe, and Mark,
Donna and me. Nintendo nights. Four-way split-
screen on a sixteen-inch TV.

 I heard you got off with Aysha from 11B.

You'd play GoldenEye, fast; walk hands-first into the dark.
One shot kills. I'd wear Charlie Blue, because
I thought you'd like it, and once, my mum's Loulou.
Some nights Donna's brother got Chinese, and we'd eat
sweet and sour chicken balls and rice, and you'd tell us how you
were saving up to learn to drive. And you'd spray Joop
to take away the smell of takeaway.

 I heard you had a hickey off Maria from the chippy.

And when Big Joe went out to smoke roll-ups on the patio,
you'd pass me his controller. Then beside you on the floor, I'd hold
my breath, cause if I made noises Mark would roll his eyes.
And on those nights I'd watch your hands: long fingers, bitten nails,
rolling thumbs on that Nintendo pad. And I'd wonder
as you found me, cornered, shot me in the dark,
if you heard the tremble in my let-out breath.

collecting rings - as fast as possible - sometimes - often - too fast

When I was ~8
And my uncle ~30
My uncle left his wife
(also ~30).
& spent ~ ½yr
Living with a ~woman
(only eighteen)

this ~girl had a SEGA MegaDrive.

(I dunno if
This was his first
Or second wife
He's had ~4.)

I didn't get
Why my mum and her sister
Were so angry
Because now
When we saw their brother
Everyone got to play
Sonic the Hedgehog.

When I got
A console of my own
I got the one
With Mario.

Fuck me, Sonic

I'm here for rings & the memory of rings.
I can remember our first time, me clenched
and hot-breathed. When I come, it's in electric blue.
The tone of Miami nights, in the Star Light Zone,
we tumble, roll, blur. Speed as heartbreak.
Fur between fingers. Suddenly we complete:
he's holding you tight & before you can breathe,
with the spin of a sign, he's gone.

Towards a Phenomenology Of Mushroom Hill Zone

Act 1.

Bounce!
Looking into the future
requires mycelial improvisation
from above or below, to leave
on a cloud. I want the shape
to leave here. Real killer
cartridge, slot me up; enter
the shape you leave
to leave here.
Knuckle down
to the playable fact of the trees.
The playable fact of the trees disappearing.

(Two of us fake being sick to play this)

Whole melodic chaos, deepest shades of chartreuse
and chestnut; becoming-animal
is sharing protagonists. We harmonise
flight and speed, blue and yellow
very lightly
hang-glide for extra life
to leave here at last on a mushroom
cloudest, pressing A to burn me out.

(Two of us best to notice)

Absent long, these decorated zones
of charming passage start to float;
platforms collapse or
have been to me zoom and wanting.

Little badnik, where are you now?
I rise on such vegetal motion
doing the loops with shameless abandon.
The poem is a hyper echidna
of only the second
light year selective.

Act 2.

Bounceless
on Angel Island, a lossy
pastoral glistens with data.
Start + Select a life together
Never knowing the trees
you rise in the forest
abundant colossus of mushroom,
mushrooOoo0000m!
All emeralds are only chaos here.
Elon would have a fit
to have it the best
Lushest eclipse of late
capitalism losing player
control—I want
you to win the old
and dormant emerald
from a dragonfly heart,
an agriculture.

The forest is only ellipsis;
a modernist classic
a special stage
for environed gamblers
of twist and star
and rarest vine...

Follow me into the Warp Ring.
Robotnik was an accelerationist
trapped in an egg. Activate jets!
Here we are stuck between two adjacent
walls of lyric. A weather machine
progressing the seasons
through green and tan and crying red
to be this explicit
shatter the satellite. Leaves
are falling in reverse. Anthemic
virescent restoration, fast
atomic harvest, pressing
the hotkey. Reader,
I'll break you out of the animal capsule
to make sweet human rain
in the hatchery of all pliable levels
this freaking axe!
a triumph
elsewhere,
spilling my rings.

In the Chao Garden

(*Modern*)

Literally named
you are cress of October. One is Neutral
and waterfall, accessing the pond
where Miles cuts
the air with orange. Here,
you may be lucky enough to find a Pumpkin.
Life in the Hero Dream sound
italicised, the river
sections us between species
of sweetness. We missed
the default tree location.
The heavenly effect
of soft, artificial wind.

(*Dreamcast*)

With rouge
your lightness is sloughing the air
to myriad. Something corrupts.
The reincarnation of a temporary egg
hatches with starlight.
Swim/Fly
/Run/Power/Stamina.
You double dash
off the edge of the island Normal.
Nightopian, slowly I give you
a life in A. Float back
through codes that still exist.
Player can access caress
and raise them.

99 Rare Candies

PLAY: APHEXTWIN__RHUBARB.WAV

1. Make of the daylight a temporary enemy
2. Learn to exhibit effective first time feeling
3. Wake up sun—sucked duly
4. The day is as pale at half past seven
5. However tragic caffeine
6. Quick attack, quick attack!
7. As I didn't teleport to get close to the rowan
8. Here in my little blue boat
9. The roads get wide with summer's receding
10. Tarmac glows at the end with smokescreen
11. I see myself cycling and feel like a hero
12. Yellow—dressed, yellow—stoned
13. Withdraw!
14. It's a cute state for potentials
15. Seductive dreameaters have their way w/ us
16. I try not to adjust
17. The water flowers of Cerulean City
18. My pastel lagoon is aching
19. Soldered quantities of berry—rich powder
20. No taste of saffron
21. A Cascade Badge
22. Plunge into sometimes, about your body
23. Intimations of zinc
24. Repel all wild channel and travel north
25. The secret is carrying moonstone
26. What hatches, huh?!
27. Along the edge, a glittering
28. Hidden item
29. Mostly a chapter for ghostly recall
30. My thoughts in the water, unfurl as flowers
31. In desperate exercise, subaquatic ballet
32. A great rate on the starriest gadgets
33. I'd like to walk around on the boulevard
34. Mostly your dying palms
35. Somebody set the oil on fire
36. Homeless for crescent and soldered

37.Whole natural definition
38.Supplementary ticket to adulthood
39.Missing links in the teeth of fossils
40.There are these dolphins that breed w/ angels
41.Low at 194,000 years old
42.Pylogenic chart in the waiting room
43.Seeing still can teach you to see
44.Tiny gathering of platitudes
45.Incomplete article
46.A core and adamant orb
47.Fled is that mushroom
48.My aurora chorus
49.Nobody's armour into
50.A sort of bittersweet balm
51.Fat malasada is recompense
52.Raw coconut, folklore
53.One of five passwords I crave in this world
54.Know your own teacher
55.Post it back with cherry lettering
56.Is it okay to fade
57.I miss the deep sea, its darkest glistening
58.Lichen loves me
59.A hyper potion!
60.Forever unsettled
61.Remember picking fruit in your father's garden
62.The studded buckle was emoji yellow
63.Mate are you a mosher?
64.Symbolisation of friendship = June @ latest
65.So much is just software
66.A well—bound parcel
67.Beautiful combat Vulpix startles
68.All of my incense
69.Precious to ever reply
70.At matter, compacted rainbows
71.Adolescent reverie turned sour
72.Acquire my strength, these fingers like trees
73.Mostly on airy ruin
74.Centrifugal concrete rerun
75.Chance leaf in the remodelled floor reborn
76.Cinnabar exception is soap

77.Construction interrupted
78.Sweetest wilderness
79.Do you miss me
80.Whole declarations ask for crystals
81.A ranch split apart at twin tombs
82.Fresh demolition
83.We are the sisters
84.A secret majority inside the caves
85.Lazy as lilies the maniac
86.Could there be a multiverse?
87.Marry me, cloud
88.All of a staunch chronology
89.Literally missing
90.A pitch of 0, no echo
91.The original deleted creature
92.Select screen, cheat mode
93.Speciality duplication
94.We are everywhere
95.Come find a collision
96.Decompressing my sprite for the myriad
97.A normal bird
98.Tendency to imbue the poison heart of program
99.As ever, I long for illusion

Pallet Town

You are eleven, and this
is the most important choice
you'll ever make.
Water will never waver.
Fire is a force of fury.
Grass plants a seed of poison.
The professor presents you a ball:
a beginning. You head north,
towards the towering hedges
where future friends may hide.
Nobody walks beside you,
but you are not alone.

Shadow Moses
after Metal Gear Solid

What happens? An island
of others, of things
never seen before
sits in the graphite sea.

All the terrible weathers,
all the very darkest
of nights are native here.
A steel-grey century

ponders its end. Creatures
you'd expect in the frozen
north, wolf and raven,
have found unusual brothers-

-in-arms. Octopus. Mantis.
A zoo that will do battle
with the world. Two metal feet
strike the earth.

Despite the cold,
a snake unfolds
from the water.

PETER HEBDEN |69

Use the sirens

After Streets of Rage (Sega Megadrive)

Splintered crates litter blue-grey
paving, roasted carcasses gone like fog
to restore, retrieve another life
as a Kruegerlike – two if you're two – dances
to your side. Your immediate reflex

is to use the sirens. You call them
once a stretched low street, even
with a lead pipe between your fingers.
Cast an advantage; let the fire reign.

Balancing trouble

After Super Hang-On (Sega Megadrive)

Freed from its cabinet and ported
to you, rumbling in your palms.
In the blues, whites, red
of Shinichi Itoh, bending the road
into his side, careful application –

that's you, now, having chosen a track
of twanging notes, cut into bits.
Inside your first minute, you
are eating dust, fallen.

Toss a vial

After Golden Axe (Sega Megadrive)

Dust sleeps, the cleaving sounds
like a fine sloshing hack through roast.

Pull a ring. Draw out the grunting
grey-skinned men and haul heavenwards

your secret. Ingredients – something dead,
something plucked fresh, the last memory

of thunder, judicious use of the A button.
Watch them dance through lightning,
and fall.

GEORGE SANDIFER-SMITH |72

Jet Set Radio

swings-in, our limber /
you, mid-speedrun round
Tokyo-To, pirate radio
blasting out big beat x hiphop hybrid sounds /
gliding slick
through neon downtown futures
on inline skates: jet-powered,
cel-shaded, anarchistic,
slipping past / law, Onishima,
with his cowlick quiff & *keisatsu*
bracelets: 'just nab 'em'
as the attack helicopter swoops & you
salmon-leap up to tag its cockpit
graffito-glorious as it
crashes & burns / dares us
to dream that we might dismantle, too
by the whirl of a can of spray paint deeds
or by style alone / *sprezzatura* for
the broken promises of the new millennium
you out-skate by dint of
the physics engine
bound for / set on
new freedoms

from **The First Day**

after The Legend of Zelda: Majora's Mask

six notes go
on & on

that they gave
& miracles— smote

these new
geometries of terror flowers

a fresh nowhere,
asleep in the

saddle, or
pursuing just (the matter):

I just want my friend back

I just— thrown clear
from Epona

& Skull Kid
cackling, groomed miscreant

& sometime felon
kicks open all

peace till gravity's root
souses my

head's naked socket
glyph-livid, as

when a mask writes
its lexis:

JAMES COGHILL |74

only me, with Dekus
drawing closer

& closer, as
a wooden dove

rattles under my skin
a dismal

too young, cot death
of the

Scrub, the voice
crushed maple wrings

to terror-bleat
at new-reflected—

a slap in the spirit
a slap

so to:
I'll a new body—

sap-sodden &
no adrenaline when

the horror begs
for its summit

let me stop
& scream it

JAMES COGHILL 75

Link's Awakening

Princessless, a blow-in.
I can be the boy I've been threatening
to be. No one knowing.
No one drawing lines across Koholint
Beach. Everyone friendly,
no one's smile is belied by a monster.
There are no monsters here,
just me. Maybe this village could be home,
my little principality.

Ghost House

after Super Mario World

There's always an exit.
A blue door to mindbleach
what you were sure would be
straightforward and empty.

There can't be that many.
What would attract them here?
Each boo, a gaping wound
creeping up behind you.

Stock still when you stare back,
eyes focused beyond you.
They can't win with you
aware. If one of them could

touch you, make you understand.
Those dates that didn't work
torn from their lives, silenced,
floating. Don't you recognise

each cut-through that you took,
each boo whose heart you broke?

Levant at the Forest Gate

after Jade Cocoon

Beetle

In the forests, our greed
animaling back at us, tails and teeth.

> Of course I love Mahbu, she does
> so much for me.

Dragonfly

There are calabas leaves being boiled –
fragrant steam sighing over sleeping heads.

> Every scar her forearms confess, each new cloth
> she hides them in, every muttering tongue
> in the village – I couldn't take it.
> We are married. I still sleep at home. When I visit her
> the hammocks sway in purple candlelight.

Spider

In one hand I hold a glowing cocoon high,
and with the other, play the tune
my father taught me before he left.

> I cried the night I first killed
> a monster in the forest. Mahbu
> was probably thinking about me.
> She told me she does.

Moth

The kickleberry is gluey and sweet
with a poisonous seed I spit out.

> The ring she gave me
> only shines when I wear it. My friend,
> the blacksmith's son, would never have given it away.

Ultima IV: Quest of the Avatar

Apple IIc

When you walk into the forest
it's *goodbye blue sky*,
fields receding, trees blinking out
behind you into the dark
until there's just a clearing. An island
in the midst of nothing. Now wait.

*

Moongate. Blue, a sudden cool impulse.
Never sure where
you would go, always hoping
for an island, an evenly fluttering flag,
someone to talk to. You step in
and the world shivers. You disappear.

*

Gold sails, blue sails. An optimist,
you run against the wind, then give in.
Names are waiting on islands and shores:
Vesper, Paws, Jhelom,
Moonglow, Trinsic, Skara Brae.
You don't need to win. Just stay.

The Hobbit, ZX Spectrum

From a little black box with a magic
rainbow stripe, we play games
learn to program, loading the cassette tape
listening to the long song
pulsing sounds, bleeps and bloops
and the crash of static.

We wait, watching as the screen
turns into a tunnel like hall
and Gandalf opens the door
to green hills. Thorin sings songs
about gold. Trolls appear from nowhere.
We fight them all. But mostly
we fight each other,
fingers poised over the keyboard
will he or won't he: Y/N

RACHEL BURNS |80

Maimed Sonnet 666: Low Health, a love poem to Doom

[Difficulty Level: Nightmare!]

Quatrain 1: Knee-deep in the Dead

I repeat passage restarting hostile lights hypnotic mental space hyperreal metal hellscape
him now again leaving I behind my eyes his eyes running the default running dazed
him again his face before a red wreck now grimly healthy portrait of me not me
running again down corridors not me wounded facility scarred base sick maze

Quatrain 2: The Shores of Hell

space yawning into abortive intersection gore decor grey doorways decoys panics
directions bait or threaten running again passages repeated
 lurid monotones I see he blasts
 vacant skittish Bosch beasts in spritely dance

JAMES KNIGHT IBM

Quatrain 3: Inferno

the music makes me not me

his face now mournful punchdrunk pulp

shooting up shooting up haha lost

machine mouth looping no me

Couplet: Thy Flesh Consumed

zero chance o me

my health low I repeat

type:gomorrah
after SimCity 2000 cheat codes

the city was compared to the garden of eden:well
 watered/ideal for entrepreneurs/
 an undulating carpet of perfect squares.and yet,

the populace was unhappy,first
 they turned to vandalism:whole blocks
 turned black overnight/fires in abandoned lots,

next came:minor rioting/
 widespread looting/
 chaos,disruption at sporting events,things

became very dark,
 the mayor responded by ignoring their needs:potholes/
 adequate schooling/pipes,

the populace became disinterested/dis
 heartened/dis

enfranchised:the streets were always sunny:

what's the point?they'd say,
the city became synonymous with
impenitent sin,

the garbage deal with Brazoria fell through,
the water agreement with Jacumba was cancelled,
the arrangement to sell solar energy to Copper Harbor was expunged,

we're sorry
there is just too much anal sex going on in your city
the emails read,

the mayor responded by
typing "flood"/
building lots of churches,

the populace:sat in the streets/
shot each other in the face/
performed oral sex on goats,

sodomised neighbours' pets/
chopped off limbs on purpose/

sneezed without covering their mouths,

allowed themselves to get fat/
 masturbated into freezers/
 swallowed slugs whole,

shot down helicopters/
 electrocuted taxi drivers/
 stamped on babies' heads,christ

thought the mayor, ignoring their needs:potholes/
free music lessons at community centres/
enough disposable income to go on holiday every once in a while,

[magiceraser]
 the plain was compared
 to the garden of eden:

well watered/ideal
 for entrepreneurs/an
 undulating carpet of perfect squares.and yet

JAMES ROOME 85

sleepwalk kid

is like smoke > rewinding as glue is in love > with love going and through
windows of yellow blues > wide-eyed a pinball summer > whose washing line defends
a kind of innocence > hanging out laughing > but not 'completely there' if you get what i mean > and shrink into
us as we were > up on the jungle-gym> *refrigerate my stale breath*

blue hair ruffled in the mute storm > why horizons grow sulking > and the grey streets bloom Millhouse > prematurely world-weary > and young enough > to know he is already too old to enjoy it > as if to reach you and to say > this moment > will come to stand for something letting blue hair burn > into the gale, locked in > outside of it, just a body > and the rest> of the house > behind doors i > can tune in, but promise > you won't fall asleep > after school > we watch The Simpsons > when > i first saw it > living in America > i was somehow scared > too young > but then > comforted > and now > on Youtube > in mock séance > VHS > tracking of analogue > to simulate > interference > ice a melodious > scratch > of cold summer > drones > a what then is now > no longer > looking

forward > to re-tread >
yesterday's tomorrow > that was > maybe never there but meadows cube > *easier to dream*

chessboard > perspective > a gloss > hands marbling a grid walk > serene > glitchcorporate > in optimism > glass river > the skating > of sheer fog > a childhood > to dream stalemate of windows > every Sunday > arrives again > through tinny speakers > American Mall > your yawn of > steps > emptied > *through thick glass*

listened to > in a room > in a house > pastoral boredom > of the South >of England
with Broadband > see the treehouse on tv > it looks high > like someone else's story returning again > and again >
to where > again > it used to be > drifting us > a second

DAVID SPITTLE 87

hand > wish > watching *echo quaint dolphins*
worn > smooth > from lazy afternoons > auctioning > dumb beckoning > infinity
of Sega blue > under milk > bottled-blink > of warm glass > to be > in a sky > so close
to rolling over > and too near > to what it was > confided in > a voice >you almost recognise those corridors > opi-
ate and sad > and bags packed > with muttering > all the sunshine

trapped > *the future was*

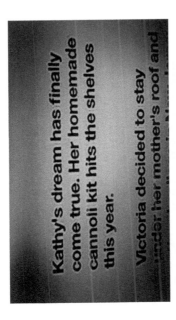

Kathy's dream has finally come true. Her homemade cannoli kit hits the shelves this year.

Victoria decided to stay under her mother's roof and

no longer ironic the vape hog > so comfortable in luxury drift that the future was a privileged glass campus > hands off > you thought you would grow up > draw the curtains

DAVID SPITTLE 89

Paperboy
Commodore 64

technology allows us to play
and replay high fidelity models / simulations / 'In the
beginning…' / spin it

/ and with myriad running models / is it more likely

─ ─ ─ ─ ─

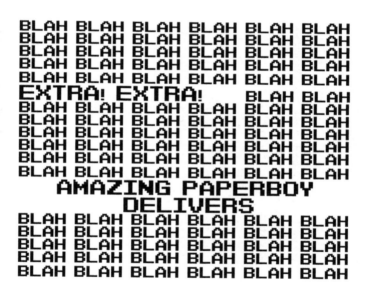

```
BLAH BLAH BLAH BLAH BLAH BLAH
BLAH BLAH BLAH BLAH BLAH BLAH
BLAH BLAH BLAH BLAH BLAH BLAH
BLAH BLAH BLAH BLAH BLAH BLAH
BLAH BLAH BLAH BLAH BLAH BLAH
EXTRA! EXTRA!     BLAH BLAH
BLAH BLAH BLAH BLAH BLAH BLAH
BLAH BLAH BLAH BLAH BLAH BLAH
BLAH BLAH BLAH BLAH BLAH BLAH
BLAH BLAH BLAH BLAH BLAH BLAH
BLAH BLAH BLAH BLAH BLAH BLAH
BLAH BLAH BLAH BLAH BLAH BLAH
   AMAZING PAPERBOY
      DELIVERS
BLAH BLAH BLAH BLAH BLAH BLAH
BLAH BLAH BLAH BLAH BLAH BLAH
BLAH BLAH BLAH BLAH BLAH BLAH
BLAH BLAH BLAH BLAH BLAH BLAH
BLAH BLAH BLAH BLAH BLAH BLAH
```

─ ─ ─ ─ ─

/ spin clouds / spin trees / spin consciousness /
a multiverse of / runs down / of glitch / of /
spin again /

─ ─ ─ ─ ─

LUKE THOMPSON |90

I aim copies of The Daily Sun at the windows
of houses and at the dustbins / knocking off lids
/ ride my bicycle as fast as I can into the car

─────

glitch

─────

The Daily Sun
Now Hiring

─────

Peter McNeeley / 36 wins in 37 fights / a record
puffed up by manager mobster Vinnie Vecchione
for / Tyson unfresh out of prison / at the MGM
Grand / the bell for the first round is about to ring
/ close up on Tyson gloves at his chin / pause /
glitch / power down /

─────

the policeman is performing squats on the pavement
/ the black dog glides

─────

all iterations of at least creeping forward into
oncoming traffic / same car same kart same
dog / running alongside all iterations of at least

─────

the black dog / a tyre moves in squares round and
round I pause to watch / never slowing or falling /
another rolls up and down the garden / up and
down
 every house has a birdbath but no birds

LUKE THOMPSON 91

—————

Jamaica Inn / five ghost hunters turn down the
lights and sit in silence listening to people who
were not there a moment ago / a wooden bench /
a horse approaches / 'Let's bring the lights back
up' / glitch /

—————

a pile of newspapers dropped on the sidewalk,
glowing / I never think about the driver / how
they have to live with this / it is all game over
but not for them / there must be a dozen cars on
this street without any wheels at all / tyres / tyres
/ black dog / a lawn mower starts and takes off
on its own into the road / spirit gardeners / glitch
/ remote control cars with no one operating them

—————

this morning my husband
cracked open an egg
and inside was a dead chick
with the face of Nicolas Cage

—————

power up / zoom zoom / glitch / more joggers more
tyres dogs one two three / lawn mower / and the
garages are all open but there are no cars no people
only tyres / darkness / men in blue suits / sprinting /
the pavements black the windows black the tyres
turn faster and faster / a man in a vest runs out / a
faceless child stops their kart on a drain / black dog
/ black dog / the jogger takes twelve steps

—————

power down / glitch / spin it

LUKE THOMPSON 92

_ _ _ _ _

ENTER YOUR NAME

GAN _ _ _

LUKE THOMPSON '93

Wild camping at Phrygia
(Battle of Olympus, NES 1991)

Skipping the formality of asking for consent
Snapping each location as it was found
We gave the wyvern's scales a spectral howk
Pored over and discarded every skelf.

As their hardnesses became opaque to interest
Struck out uphill for idle camp
Our tentfire scorched the stibbles
So no corn would have us back

Stopping at another wall, asleep
I plunged my hand into one gap
That maybe held the surface of a stream;
Birds came to sit on Helene's outstretched arm

Before we turned for home and Attica
I found newts in the pulled-up base
Of a dismantled industrial chimney
They rose up in primitive majesty.

Sun-skimming
(Elite, 1991 NES)

I press jumpsuits on the cooling plates
of a hundred-yard mass driver
built fifty years ago, or more
for a long-forgotten war
it's hard
to keep awake next to their scrapes
burning holes in the thin fabric of space.

When on B deck, short for biosphere –
although it's more oblong than this suggests –
I sit in the corona of cool blue
that emanates from Klara's stasis tube,
set to open two weeks after I'm on leave.

Secret glances punctuate the generator's jolts
and the engine's carol, tappet on ceramic
hums constant, gyring motion.

The final shift is ready for the grave
or something quite like it
where rem-sleep flicks dander
off the collar of our calendars
into the cogs of quantum calculation —
another cycle alone
and it's time for psych evaluation.

I famisht from a dream
kissed by the cool by-product
of carbon scrubbers.
Dave Braben, maintenance, I bland
light a cigarette while mag-tape whirrs and stores my words
and the starboard flight detail
dims against Lave's albedo.

RICHARD WATT 95

I fancy somewhere below there's a Jovian display
played out for crowds as Prometheus erupts
between the acts
on my 14-inch TV I bounce a ball
off the port nacelle's passing whites.

RICHARD WATT|96

Tetris Syndrome

'Life isn't fair, and all Tetris sure isn't fair.
You got to deal with what they give you.'
– Thor Aackerlund,
Nintendo World Champion 1990

Yes, there are many who doubt the
infinite game, say the death screen is
inevitable. But if we blow gently on the
cartridge, praise its pleasing *shuck,*
isn't it possible to keep rotating?
Those who play Tetris for too long
begin to see the whole world in
four-tile pieces. They stack and
unstack cereal boxes in supermarkets,
reposition the buildings on each
street. And at night, watch bright
tetrominoes slide down shut lids, an
endless chiptune *Korobeiniki*
haunting hypnagogia. Most of us crave
order's illusion. Organise to
understand. But the best Tetris players
are always sloppy, just place things
where they fit. They know the High
Score screen awaits us. That the
slowest drop won't stop GAME OVER

The Legend of Zelda: Majora's Mask

Link could not see as an adult
That as a child,
Dancing through a Hyrule glade at dusk
Beneath lavender fireflies
That it was his desire—to make the moon topple
From its evil axis onto the world.

He had created Termina in forest darkness:
A demon, his own twin brother
Twisted upside-down into pandemonium.
And look! The factory wheel stops
And the water in the well begins to freeze.
The village—a graveyard filled with sobbing ghosts.

Innocence once made a wish
For its own extinction
And became a destiny—
Returns to 6:00am of the first day
To weep in the arms of the Happy Mask Salesman,
Years flowing back and forth like water.

It is as I feared, my child…
We have run out of time.

MATTHEW KINLIN |98

Tomb Raider II

I have never been to Venice
But I have played Tomb Raider II.
I have shot a masked *goombah* to pieces
And driven a speedboat through a sheet of glass.

I have stopped to admire
Gondolas bobbing on a green-blue canal
And ran towards rats screaming in a darkened walkway,
Dived from a chandelier into bloodshed.

I think it's fair to say —
I have seen the world.

Up, C, Down, C, Left, C, Right, C, A, Start **your unrest**

Lightning Source UK Ltd.
Milton Keynes UK
UKHW020008270521
384437UK00006B/41

9 781913 642891